# MAD MAN'S DRUM

## A NOVEL IN WOODCUTS BY LYND WARD

DOVER PUBLICATIONS, INC.
MINEOLA, NEW YORK

D0366999

*Bibliographical Note*

This Dover edition, first published in 2005, is an unabridged republication of the work originally published in 1930 by Jonathan Cape and Harrison Smith, Inc., New York. The blank pages backing up the woodcut illustrations, as well as the half-title page, have been eliminated for space considerations. A new Introduction has been specially prepared for this Dover edition.

*Library of Congress Cataloging-in-Publication Data*

Ward, Lynd, 1905–1985
    Mad man's drum : a novel in woodcuts / by Lynd Ward.—Dover ed.
        p. cm.
    Originally published: New York : Jonathan Cape, Harrison Smith, 1930.
    ISBN-13: 978-0-486-44500-7 (pbk.)
    ISBN-10: 0-486-44500-3 (pbk.)
    1. Ward, Lynd, 1905–1985. 2. Stories without words. 3. Graphic novels—United States. I. Title: Mad man's drum. II. Title.

NE1112.W37A4 2005
769.92—dc22

2005048366

Manufactured in the United States by Courier Corporation
44500303
www.doverpublications.com

# Introduction

*Mad Man's Drum* is the second woodcut novel by Lynd Ward reprinted by Dover Publications. His first, *Gods' Man*, was released by the publisher in 2004. These reissues reflect the current popularity of graphic novels with the American public and the growing interest in the pioneering efforts of artists like Ward.

The artist's six finished woodcut novels, *Gods' Man* (1929), *Mad Man's Drum* (1930), *Wild Pilgrimage* (1932), *Prelude to a Million Years* (1933), *Song Without Words* (1936), and *Vertigo* (1937), began to define the standards that dominate in today's visual story-telling. Using black-and-white pictures, the novels explore themes such as the price of artistic fame, the ethical dilemma of bringing children into a fascist world, and the devastating effect of the Depression on the lives of Americans. Their images open a door to the subconscious with gripping symbolism that uncovers private fears, joys, and desires. Similar to other discrete image-based narratives, Ward's novels require the reader to unconsciously create the needed closure in the flow of action. Ward prided himself on insuring that each print was visually exact enough to enable this cohesive flow. An uncompromising artist, he was known to discard blocks that he had spent hours engraving if the position of a figure or an object disturbed the visual balance of the plate or interrupted the narrative.

Ward was born on June 26, 1905, in Chicago, the second of three children of Daisy Kendall Ward and Dr. Harry F. Ward, a celebrated Methodist minister, writer, and outspoken promoter of social activism. Ward spent his childhood reading picture books and drawing. His wife, May McNeer, in an essay for the *Horn Book*, asserts that Ward's interest in pictures and an artistic career was encouraged by the fact that "in the first grade, he made the astonishing discovery that the name Ward was really Draw turned backwards." The artist eventually

attended Teachers College at Columbia University, where he met the future children's book author McNeer. After graduating in 1926, they married and departed to Leipzig, Germany, where Ward studied for a year at the Academy for Graphic Arts. While in Leipzig, he discovered the woodcut novels of the Belgian Frans Masereel, specifically *Die Sonne* (The Sun). Upon their return to the United States, Ward took his portfolio to publishing firms and secured some book illustration jobs. However, what advanced his career decisively was the publication of his first woodcut novel, *Gods' Man,* which he had been working on since discovering Masereel's work. Masereel's woodcut novels were not distributed widely in the United States and did not receive critical attention outside Europe. As a result, the uniqueness of a book without words caught the interest of the American public, and *Gods' Man* became a success, selling 20,000 copies and going through six printings in four years. Its publishing history is even more impressive considering that it was published the week that marked the beginning of the Depression.

The success of *Gods' Man* was followed the next year by *Mad Man's Drum*, which featured a more complex plot, rich symbolism, and increasingly detailed pictorial composition. The artist also used a larger assortment of engraving tools to achieve greater detail in the novel's images. With the increased number of characters in *Mad Man's Drum*, the quantity and complexity of their interactions grew. In turn, Ward was pressed to make his characters identifiable with distinct physical features, clothing, or other familiar objects. For example, the novel's protagonist is unmistakable, with a long, sharp nose and a high receding hairline. His wife wears a dress with a pattern of black-and-white squares, while his daughter wears a recognizable brooch and a flower waistband. These distinctive physical features are also often symbolic. For example, the flower on the daughter's waistband can be seen to represent her purity and innocence—she loses her waistband to a young man with numerous flowers decorating his vest. Ward's symbolism extends beyond characters to objects: the floral motif also appears in the petal-shaped stucco on the seducer's house. (Notice also that his house has a rooster rising boastfully as its weathervane and a gate constructed with ominous spears.)

The use of dramatic facial expressions is expanded in *Mad Man's Drum,* as Ward focuses on a larger range of emotions, such as the resentment that the protagonist's wife displays before she decides to

leave him, as he sits complacently walled in behind columns of books. Some of Ward's best images involve these exaggerated expressions—for example, the look of terror on the mother's face before she slips on the stairs and falls to her death, or the protagonist's distress after he loses his daughter. In both of these images, Ward simply draws the character's face as two white circles inside a dark band.

The additional tools that Ward implemented for the novel included the multiple tint tool, used to create straight lines, increase depth, and bring further attention to a person or an object. A good example of the effective use of this tool is in the concluding section of this book, in the print where the seducer is lounging against a tree. The sky is displayed in horizontal lines, in contrast to the combination of single vertical lines from the trees and the figures. The print also shows Ward's use of small, rounded gravers to jab out objects such as the leaves on trees.

The psychological insight demonstrated in *Mad Man's Drum,* and in Ward's subsequent woodcut novels, did not escape notice from the academic community, which at the time had a growing interest in Freud, Jung, and psychoanalysis. Two prints from *Mad Man's Drum* were used by the psychologist Henry A. Murray in the 1943 *Thematic Apperception Test (TAT),* which used pictures to uncover personality traits. In addition, Ward later drew a set of 42 pictures, from which 20 were selected for the 1948 *Symonds Picture-Story Test,* which focused primarily on adolescent fantasy. May McNeer perceptively remarked in her memoirs that "Dr. Carl Jung would have enjoyed meeting Lynd Ward."

Following the success of *Gods' Man* and *Mad Man's Drum,* publishers brought out a handful of wordless novels. Among the unique works in the genre was Otto Nückel's *Destiny: A Novel in Pictures* (1930), published by Farrar & Rinehart. This tragic story of squalor in the life of a working-class woman is a psychological masterpiece told in over 200 leadcut prints. Another wordless novel by Farrar & Rinehart was *The Life of Christ in Woodcuts* (1930) by the Philadelphia illustrator James Reid. Coward-McCann published *Alay-oop* (1930), by William Gropper, which examines the lives of two acrobats and a singer, using a distinct dream sequence. Doubleday, Doran & Company published a lampoon of the genre of the wordless novel by the cartoonist Milt Gross called *He Done Her Wrong: The Great American Novel and Not a Word in It—No*

*Music, Too* (1930). *Childhood: A Cycle of Woodcuts* (1931), by the Czechoslovakian artist Helena Bochoráková, considers middle-class life. *My War* (1931), by the Hungarian István Szegedi Szuts, displays the horrors of war. *Abraham Lincoln: Biography in Woodcuts* (1933) is a unique depiction of Lincoln by Charles Turzak.

When the popularity of woodcut novels waned, Ward continued his work as a book illustrator. He was highly regarded in the United States as the illustrator of books for George Macy's Limited Editions Club and the Heritage Press. He was also a prolific children's book artist, illustrating over a hundred books for Landmark Books, Illustrated Junior Library, and others, including several books written by his wife. Ward drew images for Elizabeth Coatsworth's *The Cat Who Went to Heaven* (1931) and Esther Forbes' *Johnny Tremain* (1943)—each won Newbery Medals—and was awarded the Caldecott Medal in 1953 for *The Biggest Bear*, which he both illustrated and wrote. During the last years of his life, Ward returned to work on a woodcut novel, which was published posthumously in 2001 as *Lynd Ward's Last Unfinished Wordless Novel*.

Many artists have heralded the importance of Ward's woodcut novels since their publication in the 1930s (*Gods' Man* came out in 1929). Will Eisner asserts in *Graphic Storytelling* that Ward "stands out as perhaps the most provocative graphic storyteller in this century." This Dover reprint brings evidence of Eisner's claim to a new generation of readers, who can now become acquainted with the mastery of Ward's storytelling skills and his insight into the human psyche.

DAVID A. BERONÄ

David A. Beronä, Director, Plymouth State University Library, New Hampshire, has written about woodcut novels and pictorial narratives for the *International Journal of Comic Art*, *Matrix*, *The Comics Journal*, *Print Quarterly*, and *Antiquarian Book Monthly*.

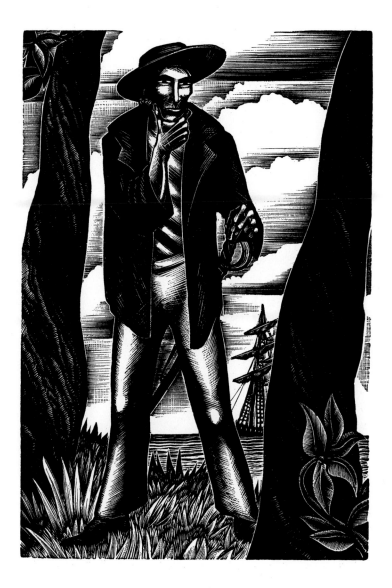

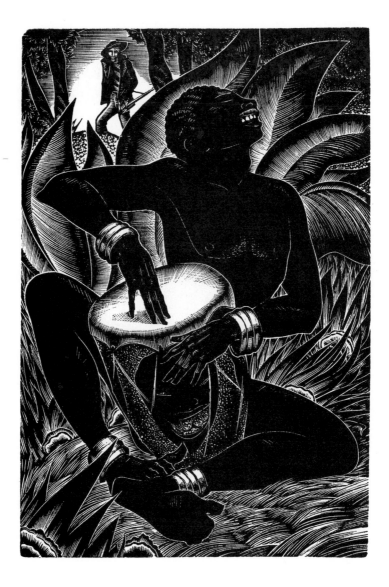

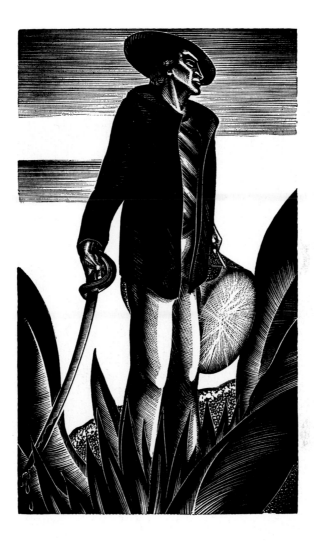

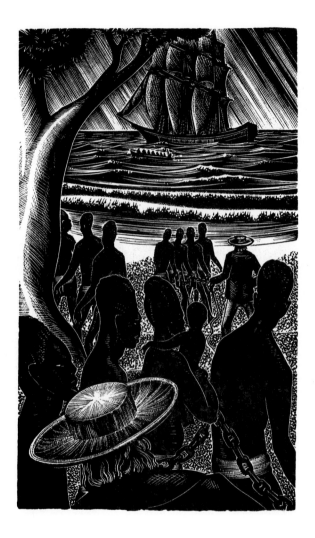

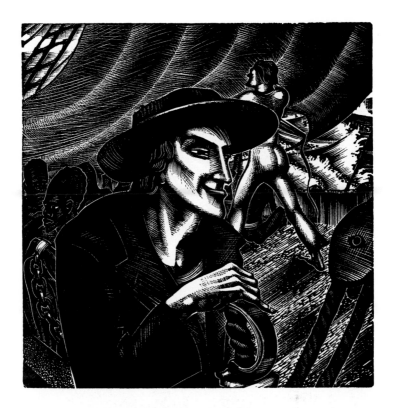

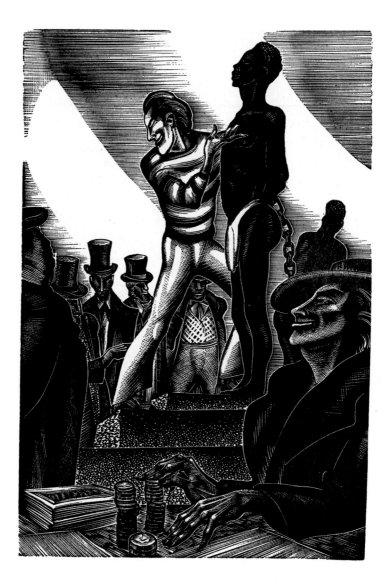

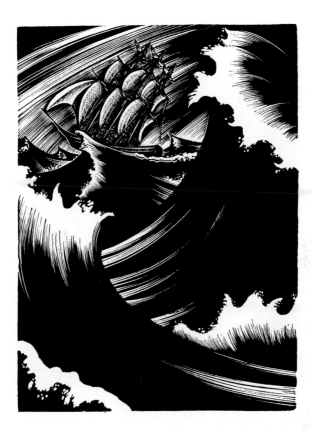

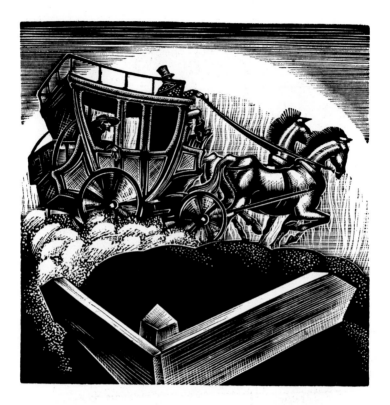

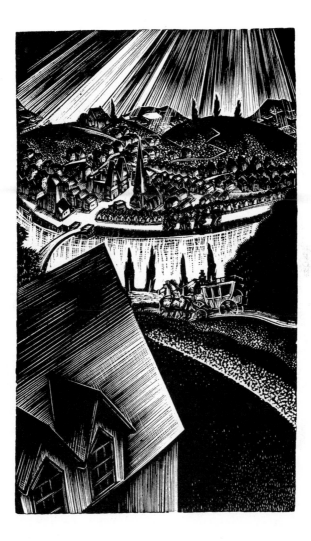

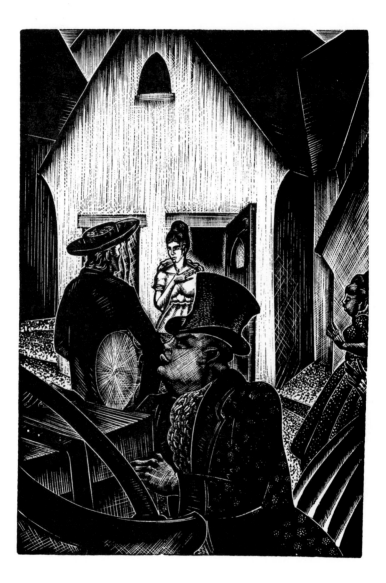

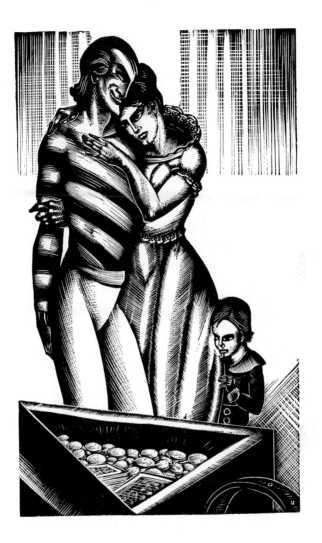

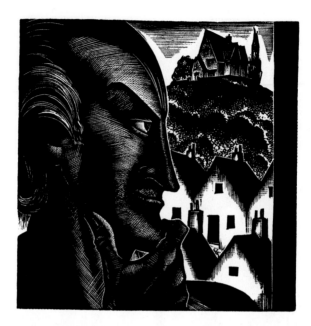

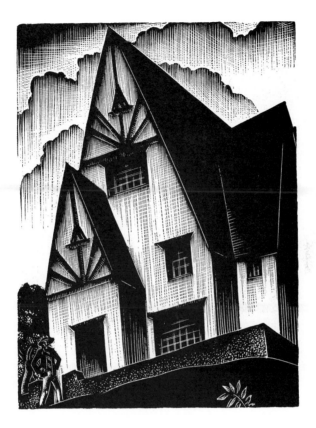

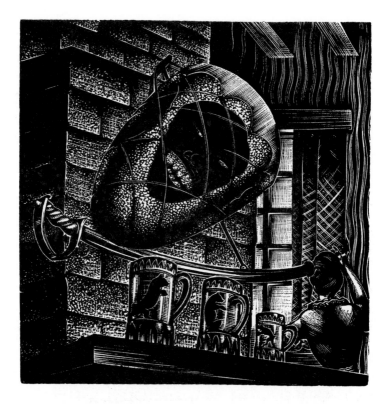

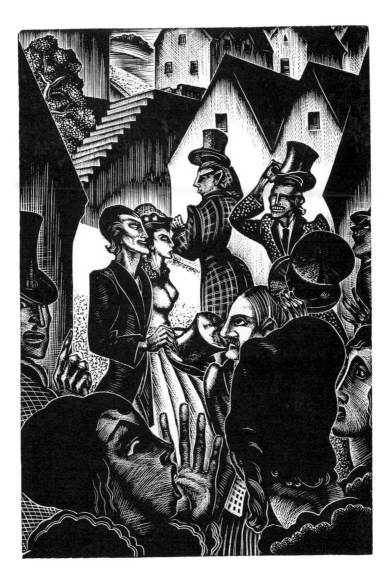

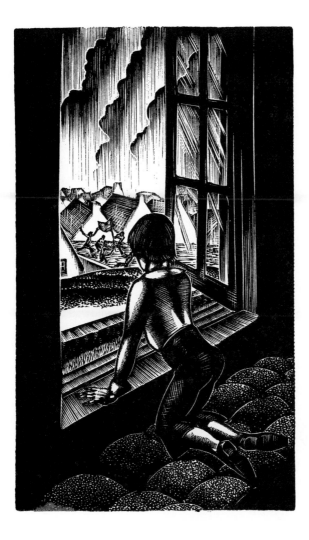

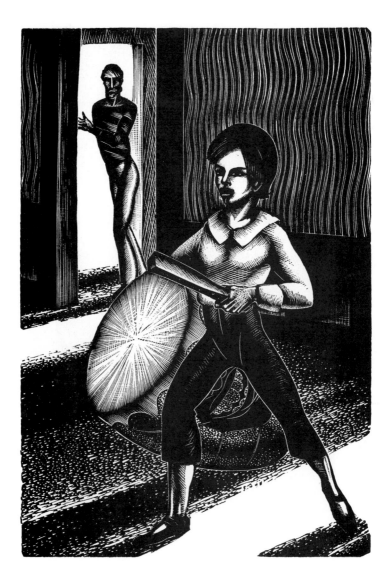

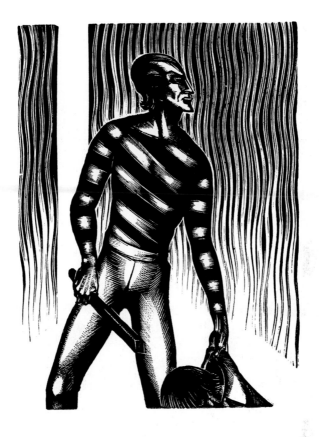

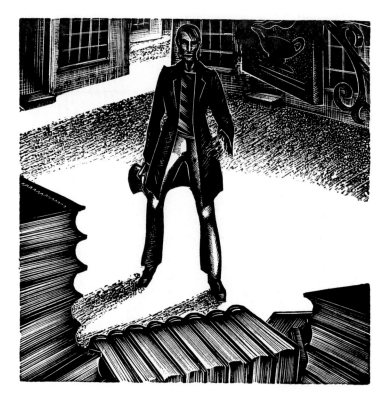

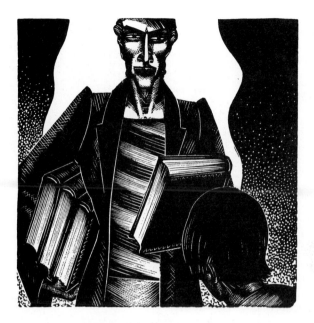

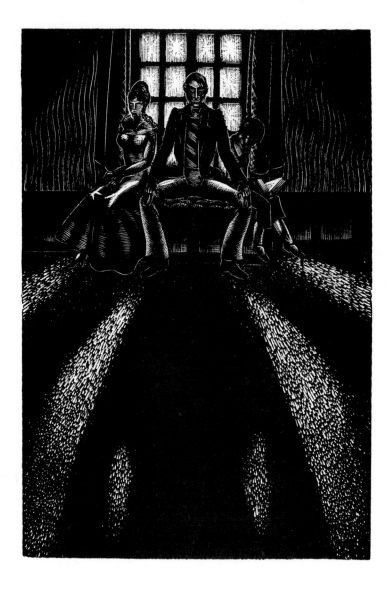

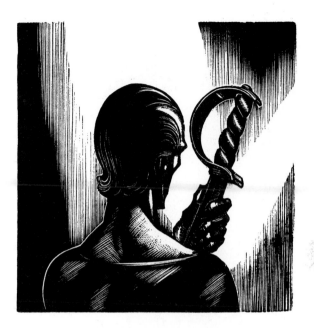

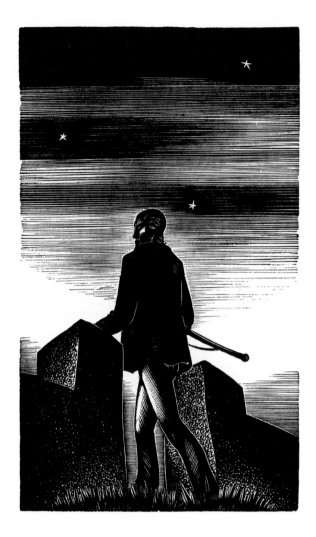

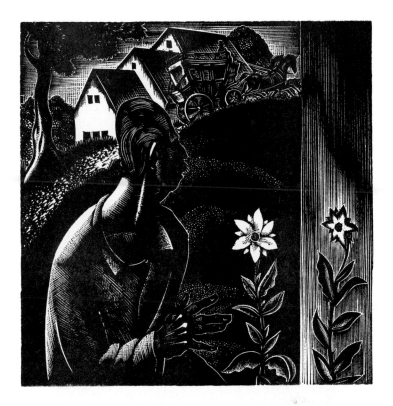

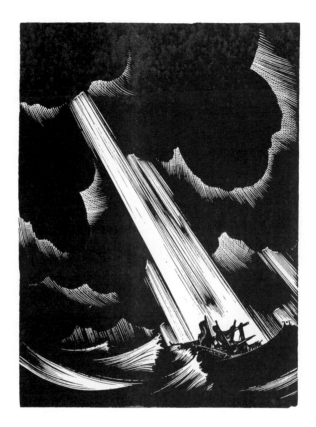

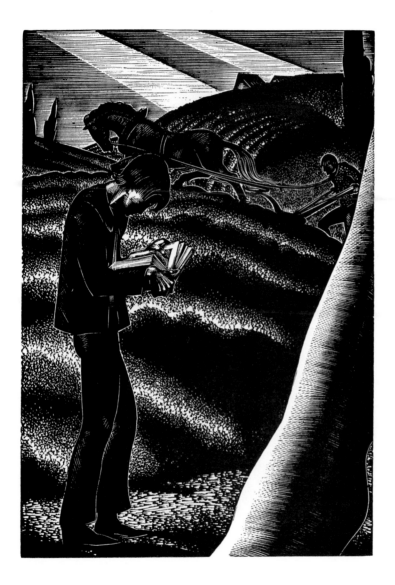

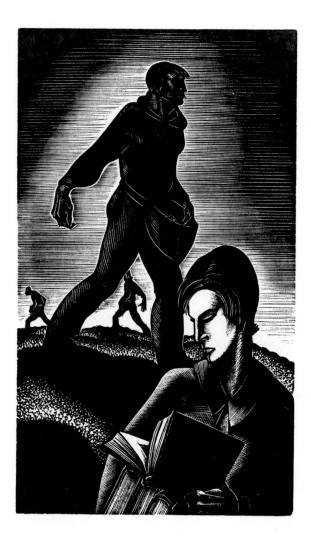

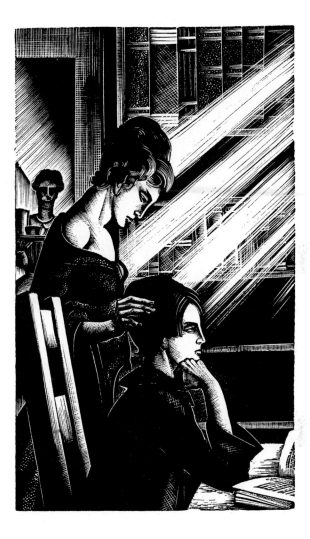

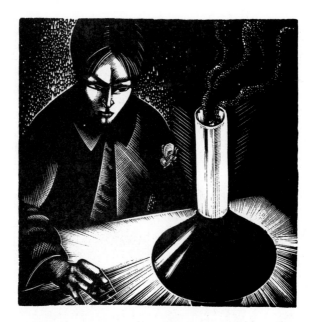

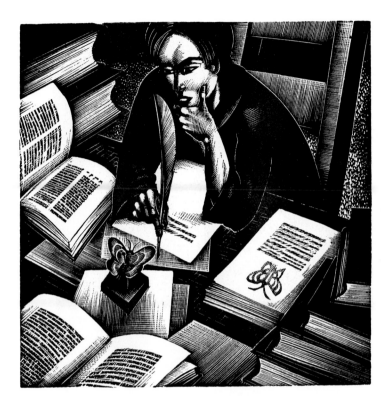

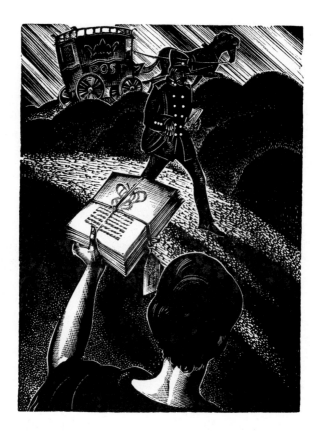

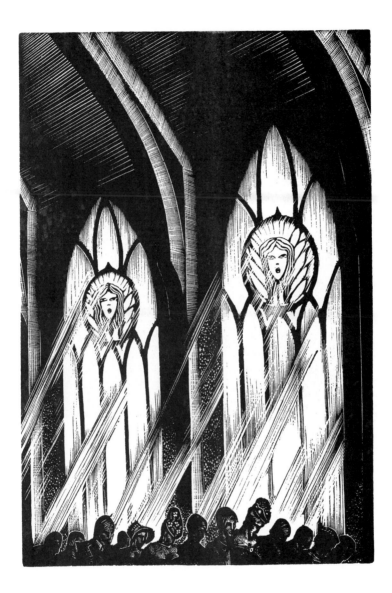

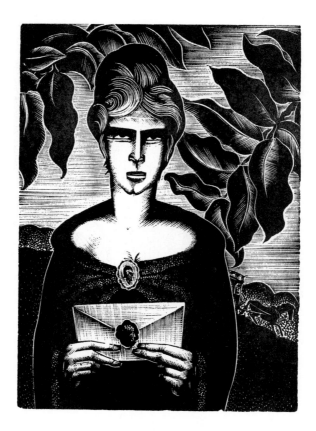

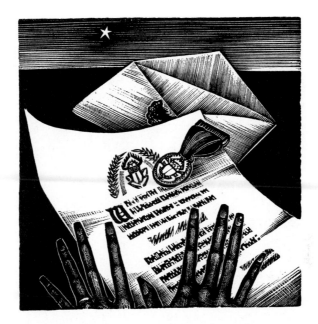

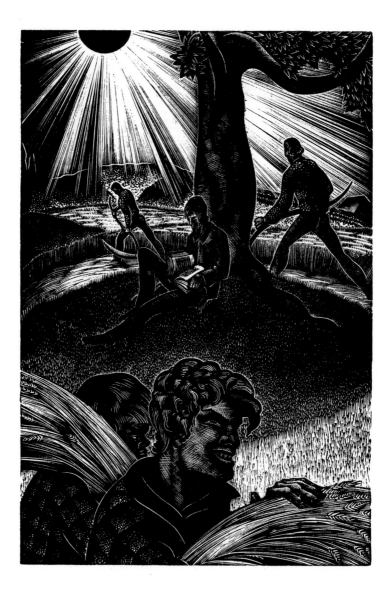

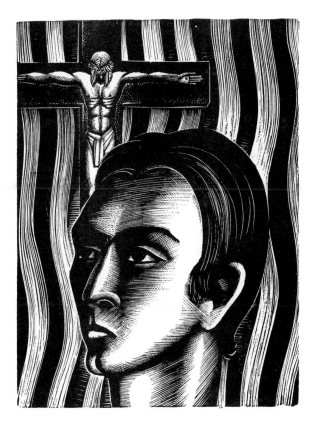

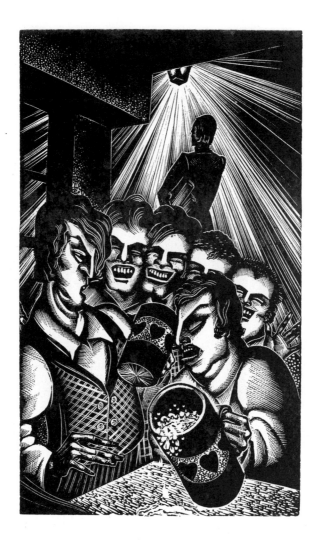

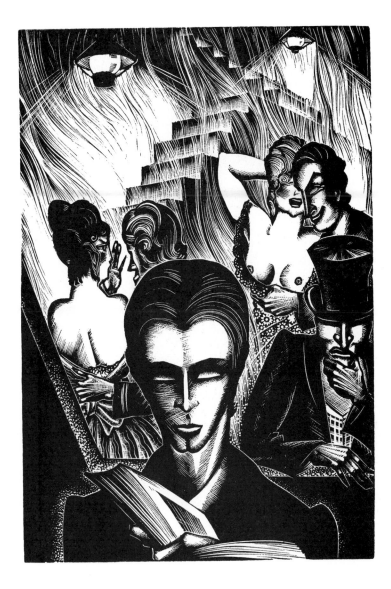

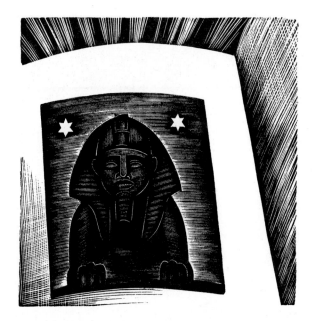

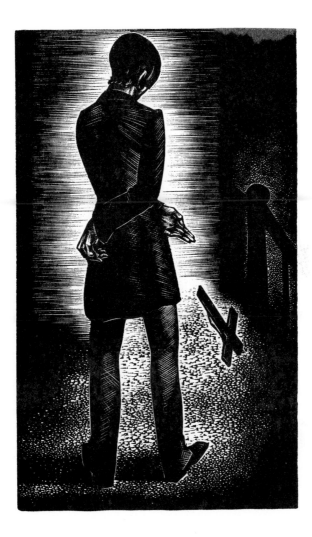

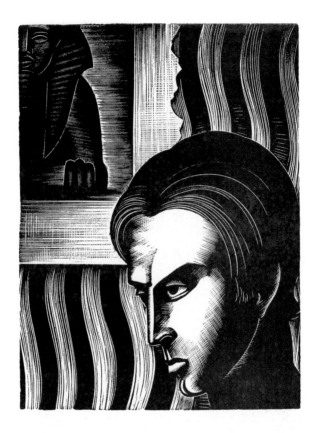

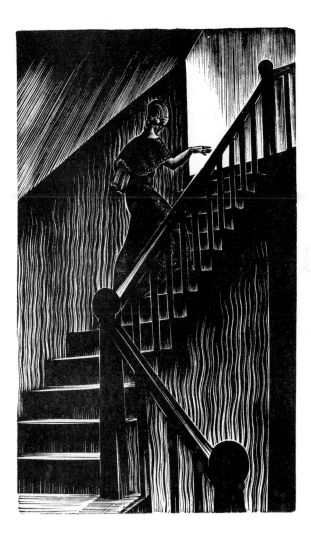

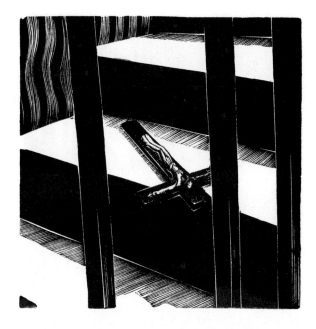

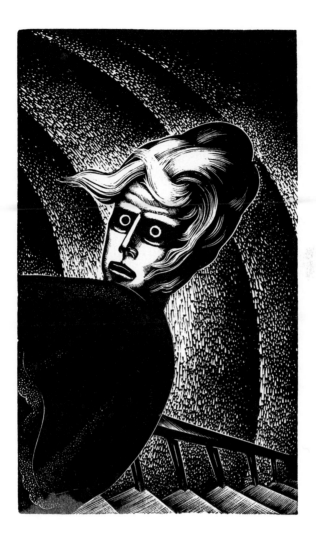

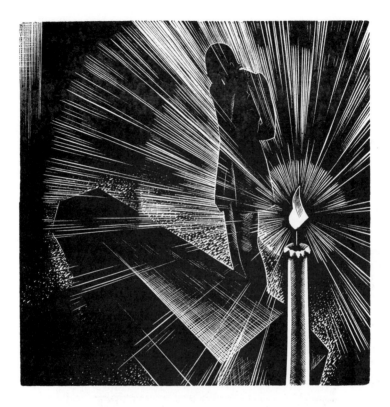

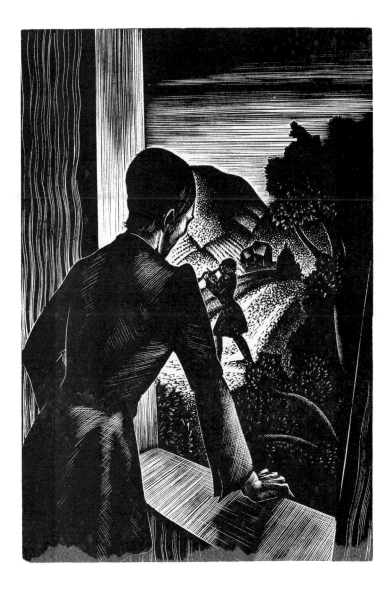

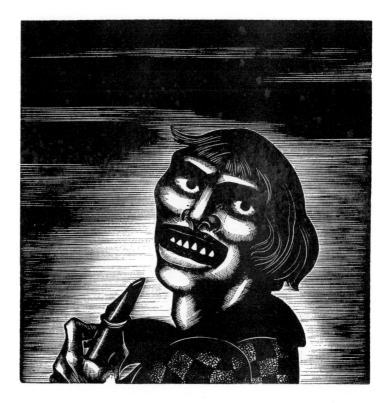

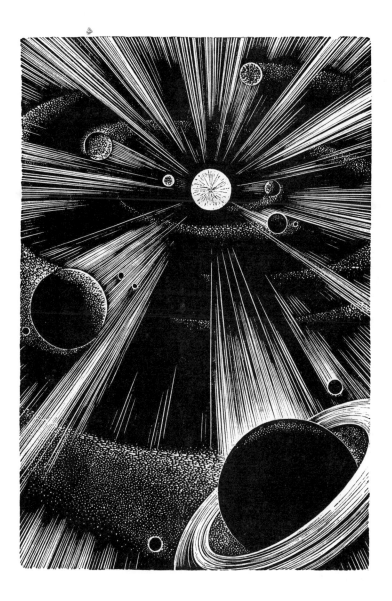

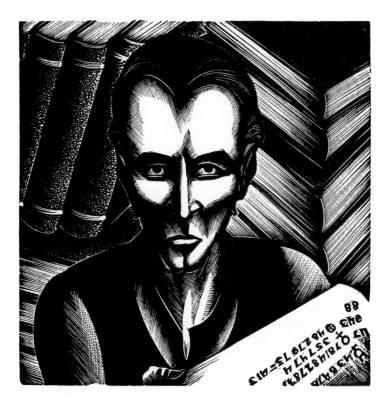

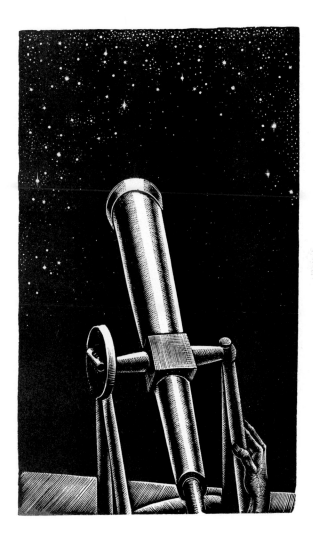

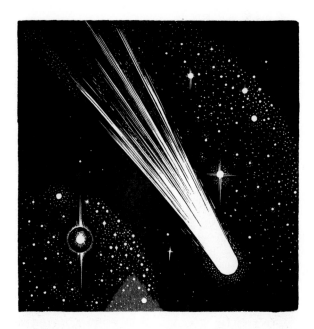

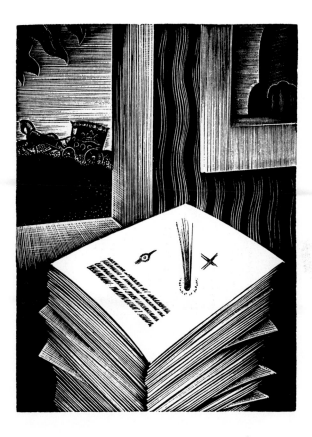

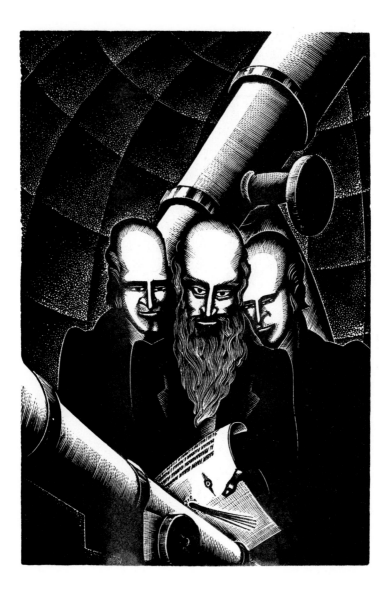

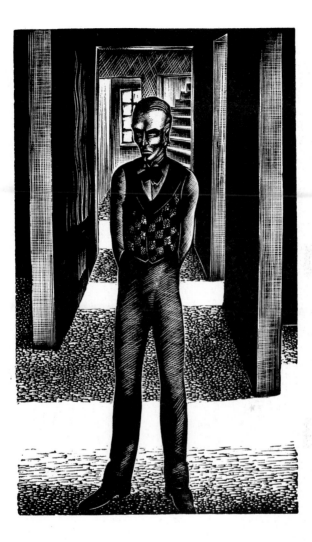

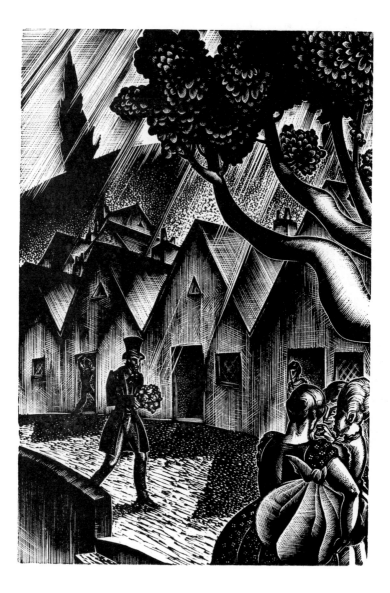

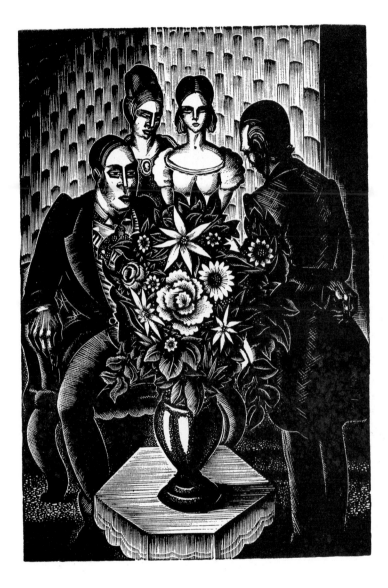

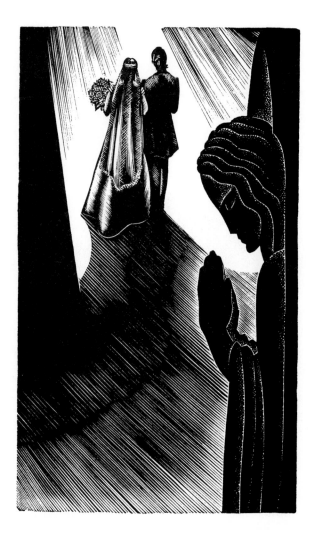

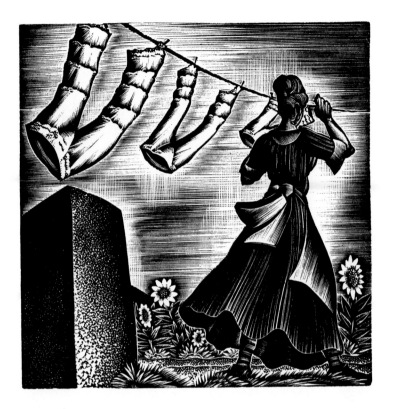

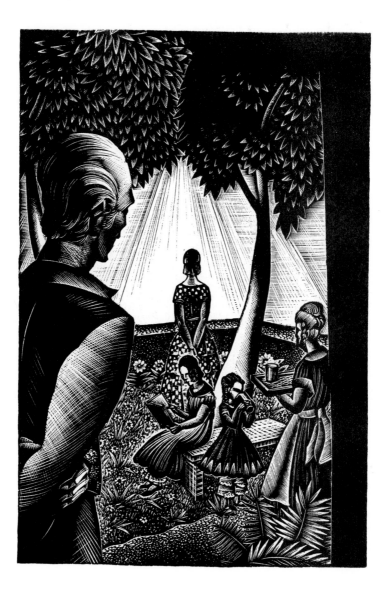

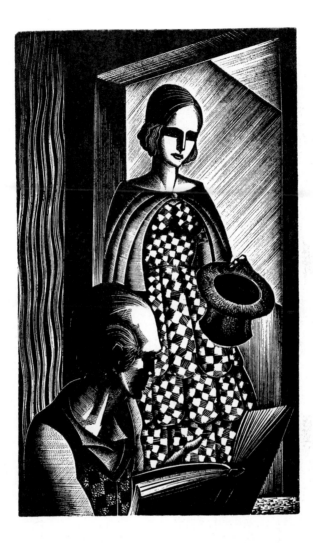

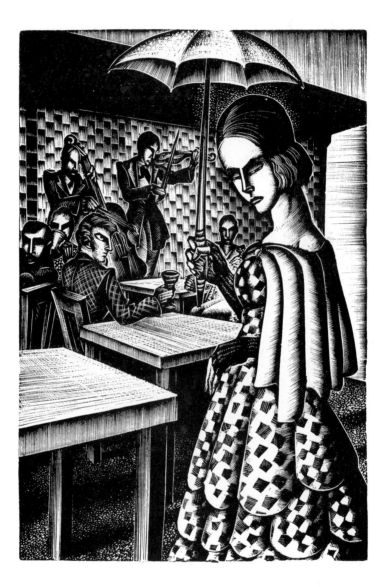

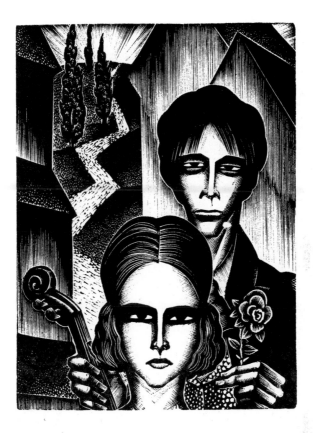

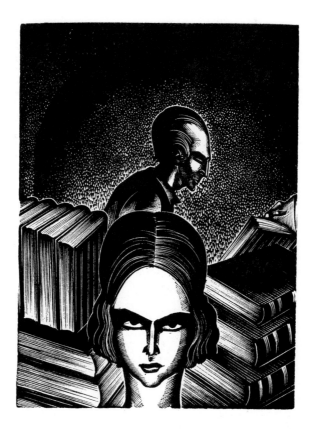

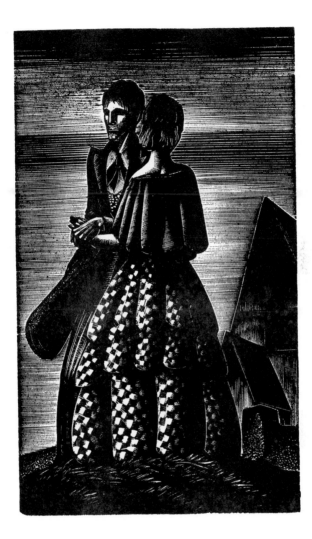

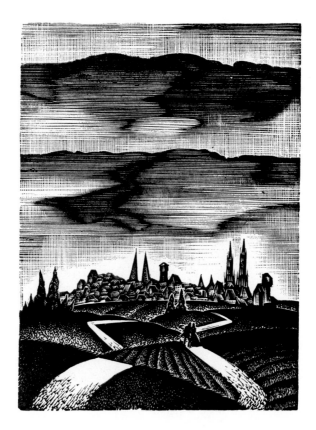

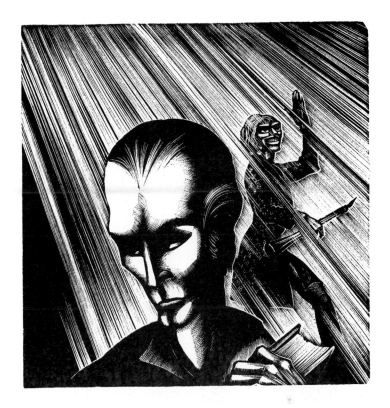

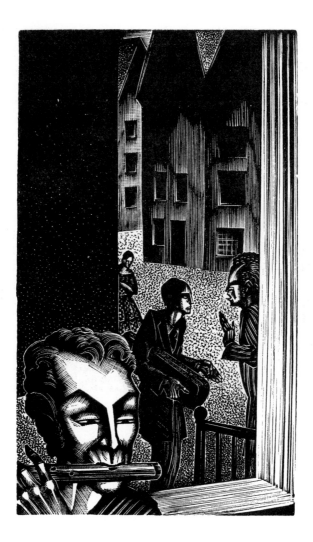

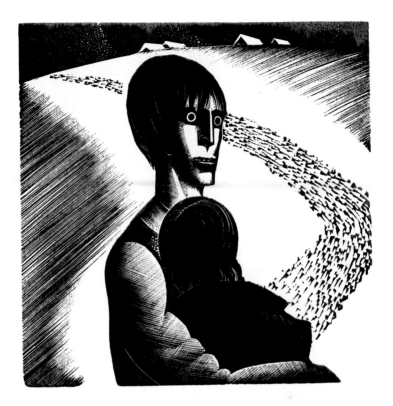

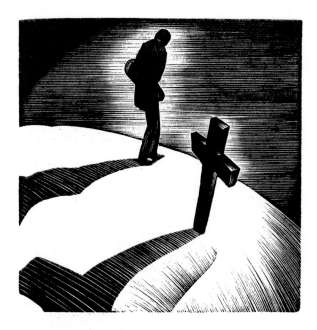

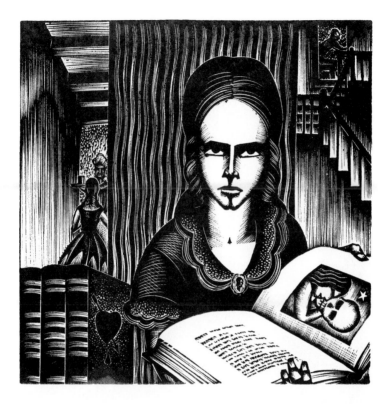

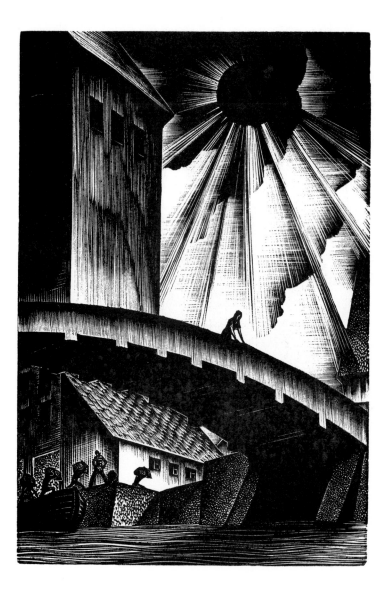

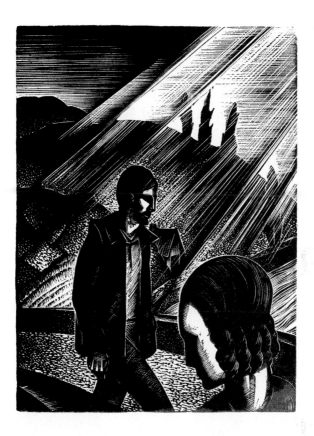

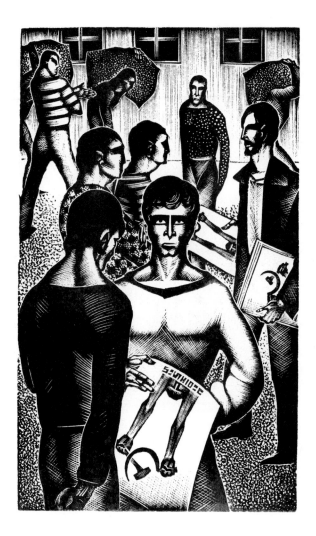

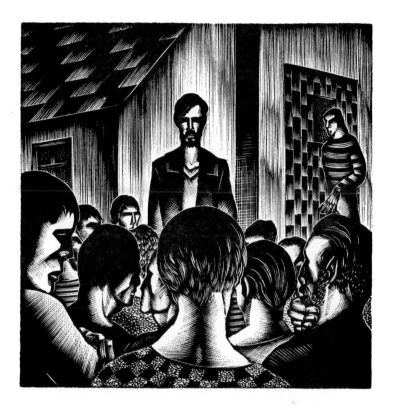

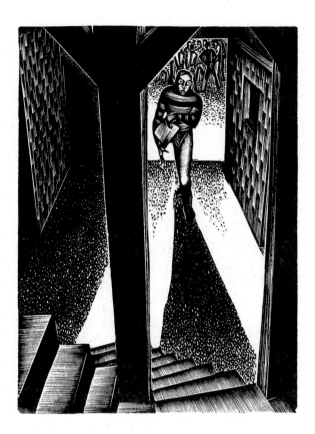

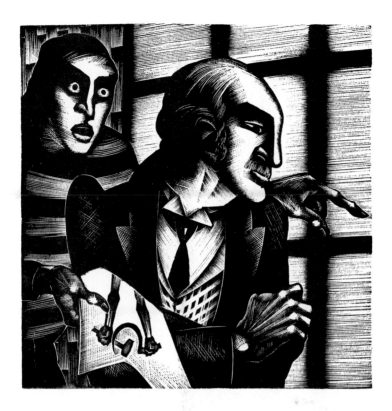

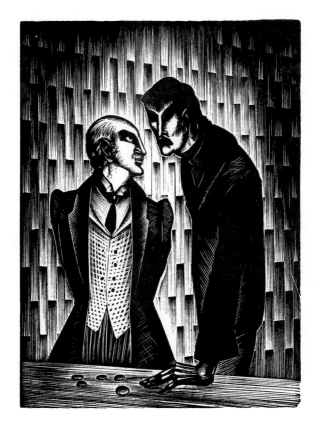

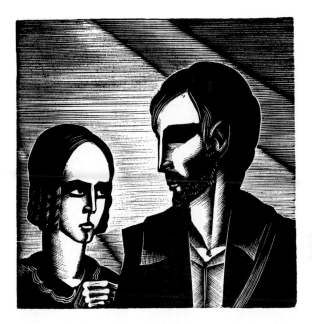

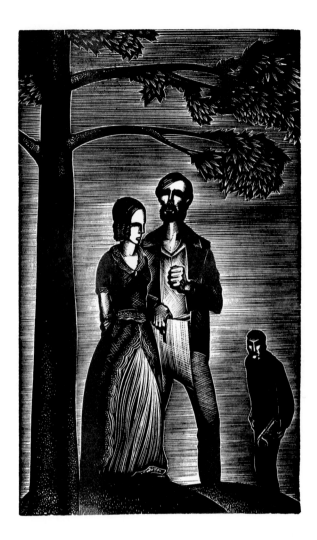

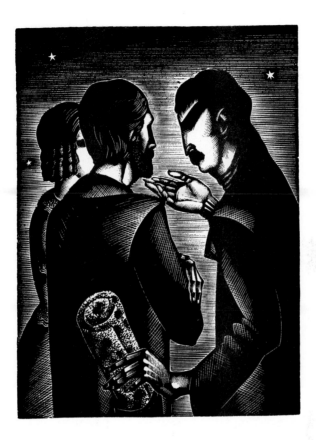

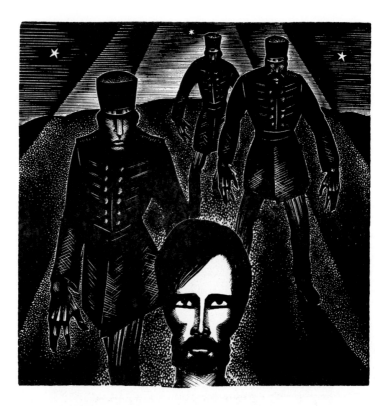

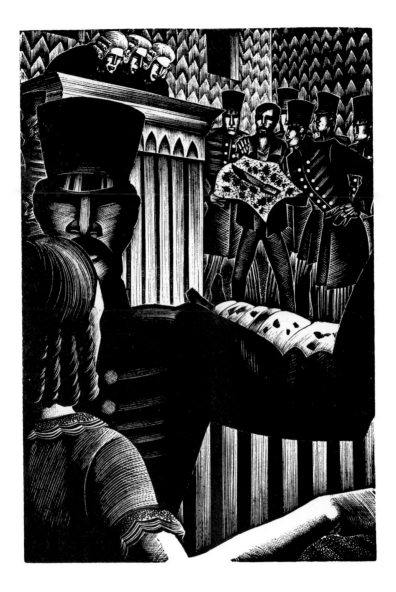

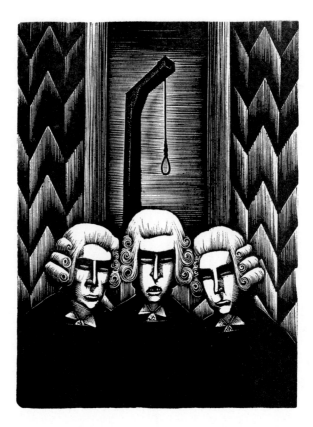

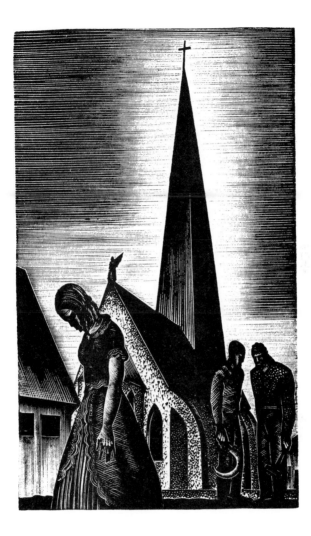

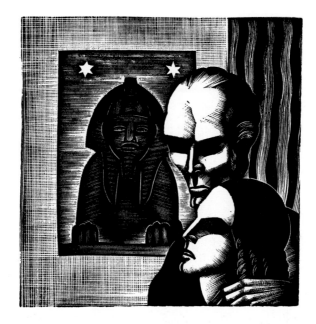

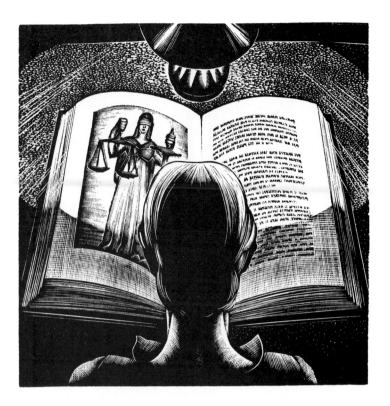

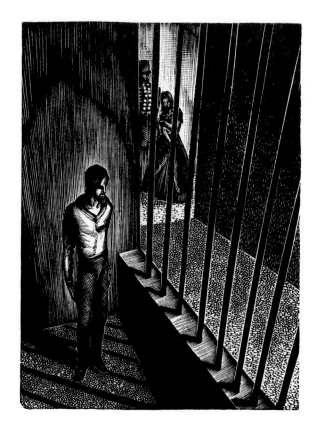

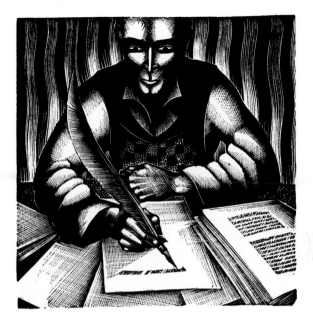

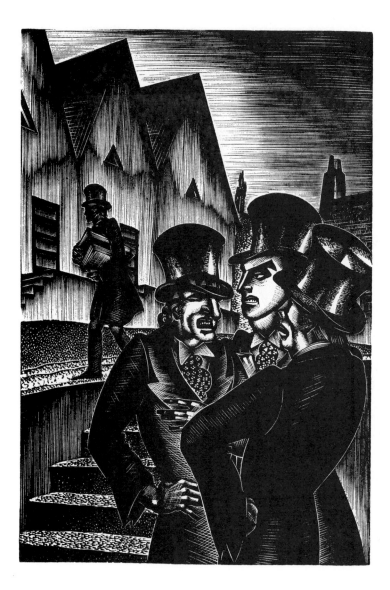

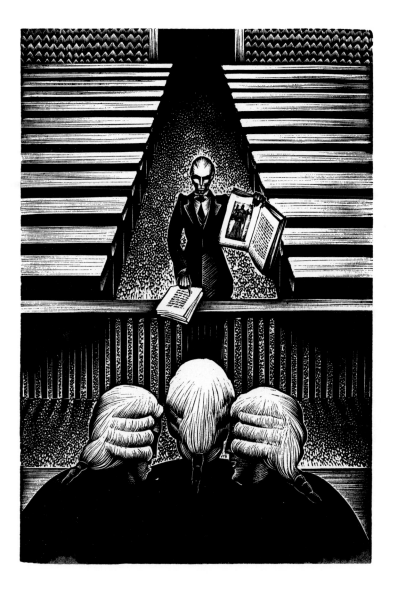

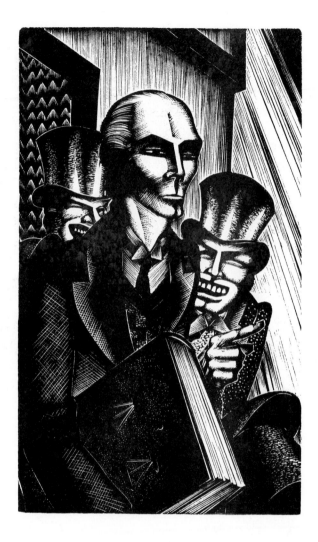

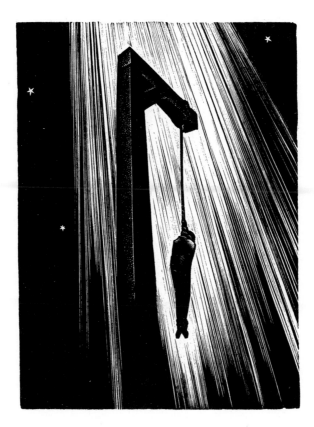

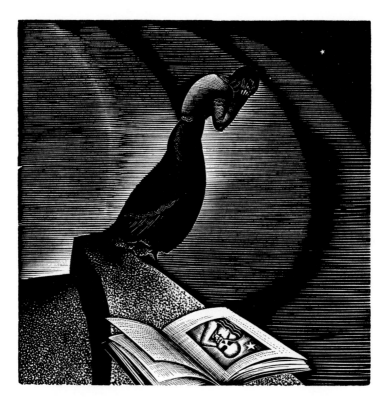

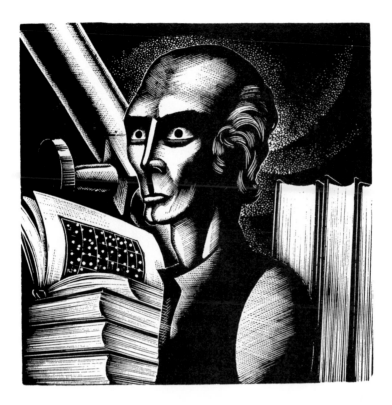

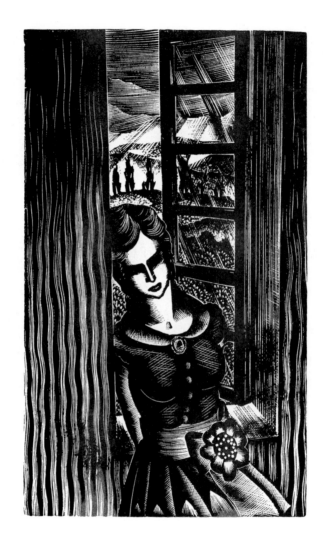

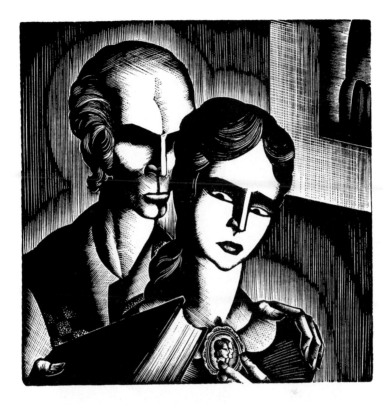

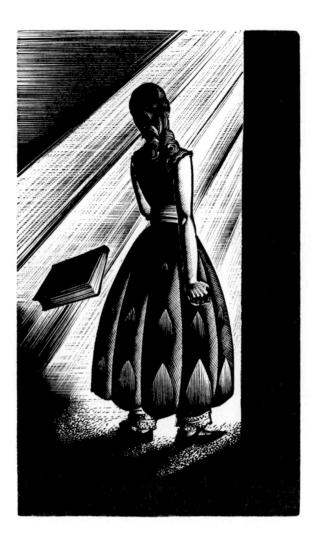

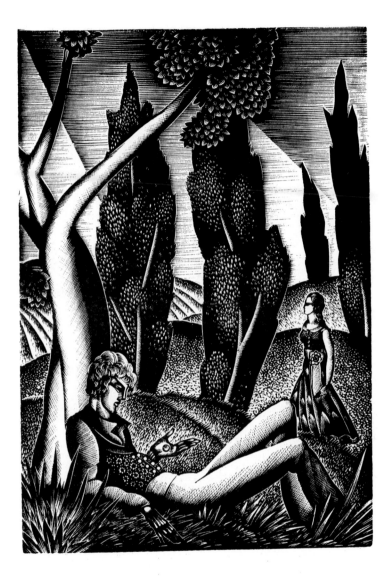

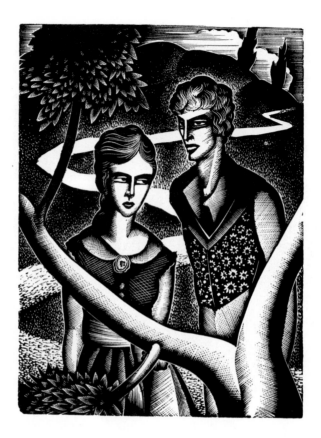

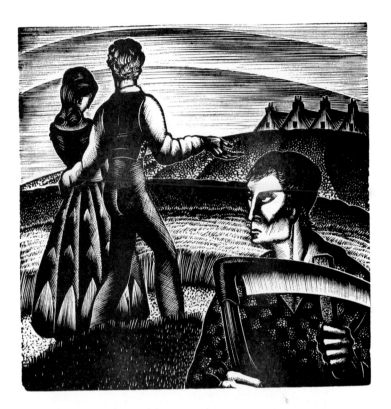

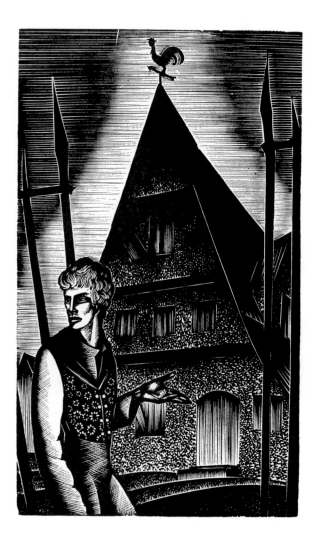

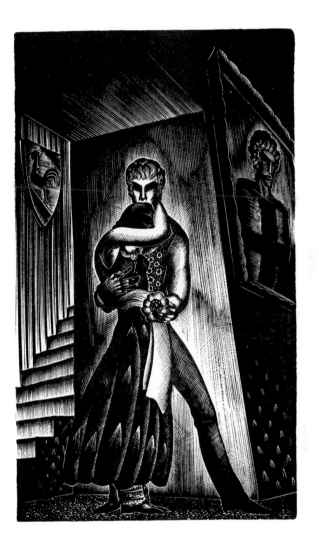

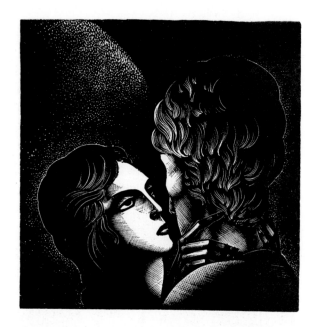

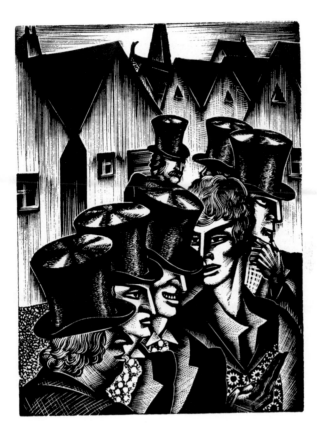

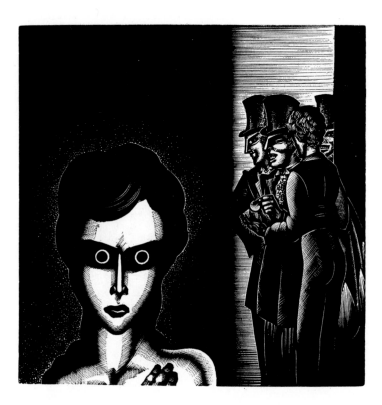

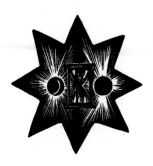

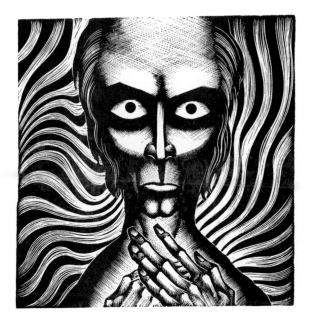

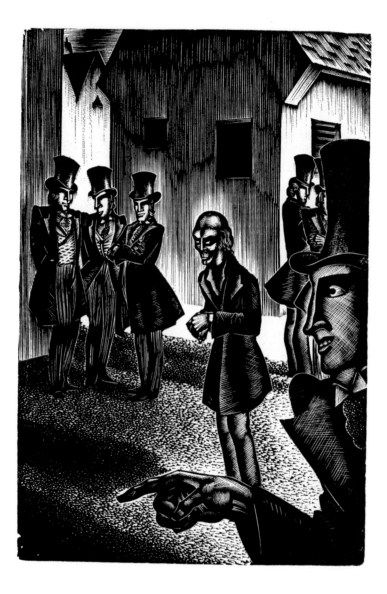

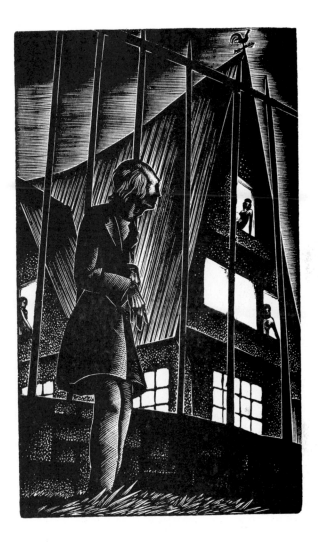

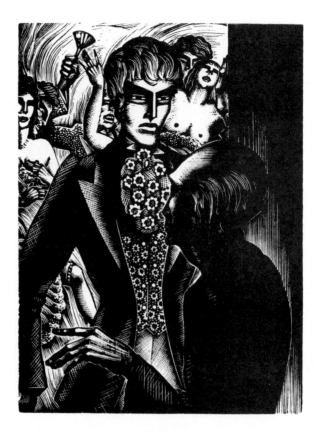

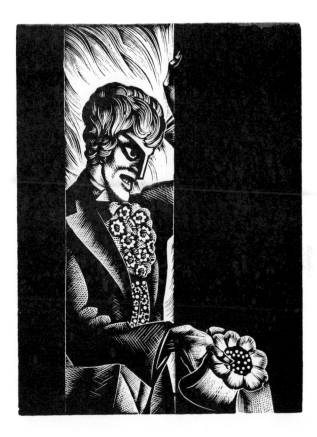

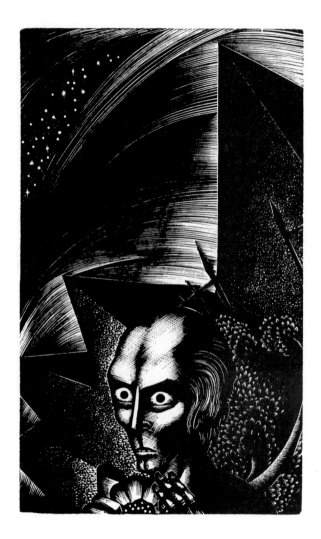

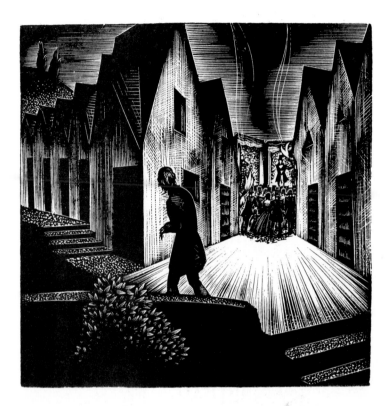

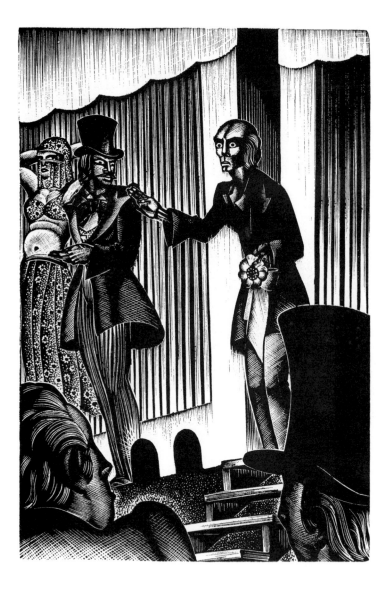

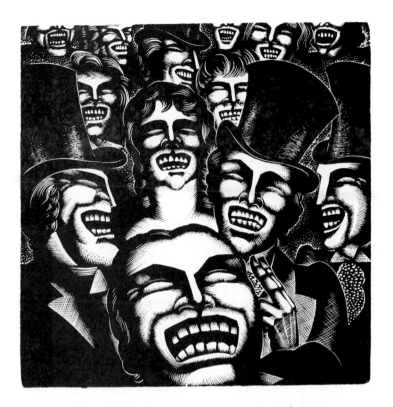

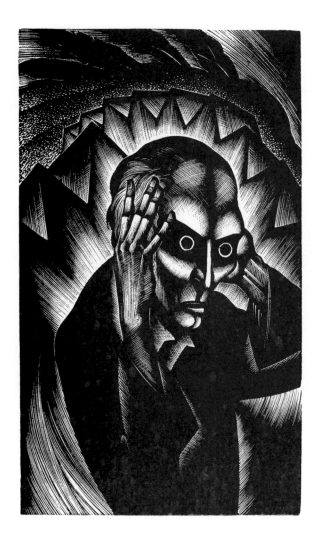

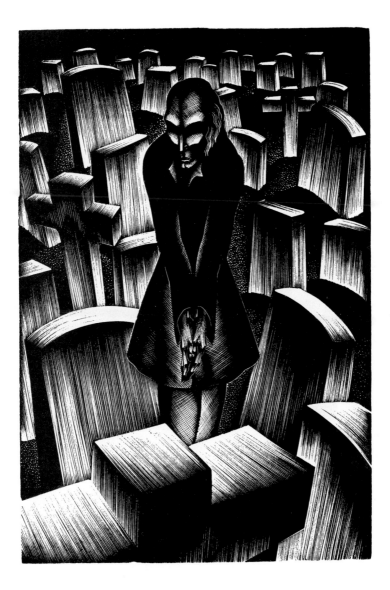

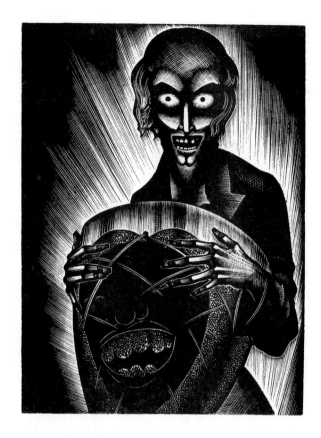

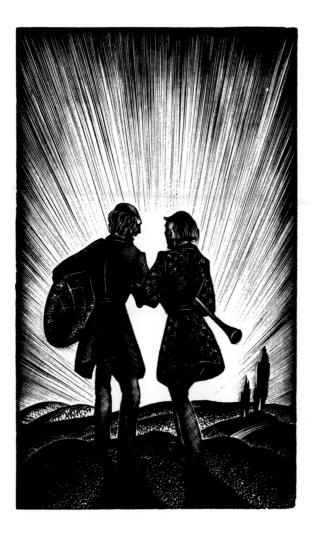